A day with Degas

Created and written by
SIMA LEVY

Illustrated by
Justin Morcillo

Mothers Art World
New York

Degas's Images Provided By
Collection/Bridgeman Art Library

D15515301

ISBN: 1491297743
ISBN-13: 9781491297742

Published by
Mothers Art World, Inc., New York
www.Mothersartworld.com

*In Loving Memory of
my brother Donny Samouh*

Summary

Paris was excited to paint her ballet dance 'trio' in her mom's (Ms. Simone) art class. Her inspiration was the style of the artist Edgar Degas. She was able to capture her own movements, but had difficulty illustrating the gracefulness of her friends Justine and Mary and wished to meet Monsieur Degas for artistic guidance. Together with her best friend Manet, they say the magic word three times: "Wackadoey, wackadoey, wackadoey," and then away they blewy to the past to meet Degas in Paris, France. The artist teaches them to draw, erase, perfect and redraw. Although Degas is an impressionist painter, he takes time completing his works and Paris learns that she should do the same. She returns to ballet school to sketch Justine and Mary and the outcome is perfection!

Read *A Day With Degas* and you will experience a "Manet Day," learn to use your imagination to improve your art, and feel coo-cooey wackadoey. So what do you say?

Illustrated by: Justin Morcillo

"Degas's Ways," lyrics by Sima Levy, music by Cory Dibona and Peter Scarlata, performed by Kristen Ungar and Paris Levy

Song available on www.mothersartworld.com

I dedicate A Day With Degas to the beautiful, intelligent, sweet and welcoming kids at Cohen's Medical Center, of the North Shore-LIJ Health System, New York.

Each month I prepare a lesson about a famous artist and am excited to arrive at the Cohen classroom to set up all the props and information on the blackboard, just like in Ms. Simone's art class. I'm fascinated every time I teach by how stimulated the children are by the lessons, becoming distracted from the stresses of their daily lives while absorbing the information like sponges. They have so much to say as they view the art, that I learn a thing or two from their personal interpretations! My classroom is a collaborative, fun art appreciation class, where we have open discussions about an artist's life and his style of painting. I incorporate games such as "I Spy" to help them recognize all of the artistic elements in a painting, and finish with projects inspired by the artist of the day.

Acknowledgements

First, I would like to thank my wonderful husband Jason, for believing and supporting my vision. My loving children Jordan, Logan and Paris for inspiring me to write characters that remind me of their personalities, and for always wanting to listen to my ideas and share their opinions.

Thank you, to my teachers and mentors, the late Diane Darst, Alice Coleman, and all of my art history professors who inspired me and taught me that art is fun, full of information and rich in history.

Thank you, Megan McKenzie for being a loyal friend, for your words of confidence, and for believing in my vision.

Thank you, North shore- LIJ for allowing me to share my knowledge and passion of art history, which can be intimidating to children at first. My goal is to eliminate that factor and teach in a way that is entertaining, informative and interactive.

Much thanks to Ann Marie DiFrancesca, Randee Bloch, Megan Thompson, and the rest of the Child Life staff who amaze me every time I visit.

Most importantly, I want to thank G-d for giving me the opportunity to give back to others. Thank you for Your guidance; I am, as we all are, your children. May You bless the kids that need healing, may You grant them full recovery. Amen and Amen!

Buzz, buzz, buzz! The alarm is hounding.
"Good-bye, sweet dreams," it's sounding.

Time to get ready; adventures await.
So hurry up! Get moving! You can't be late!

"Paris," Mom calls, "don't forget your art supplies."
"I'm packing them now," she replies.

Off to school to join her friend Manet,
She can't wait to begin the day!

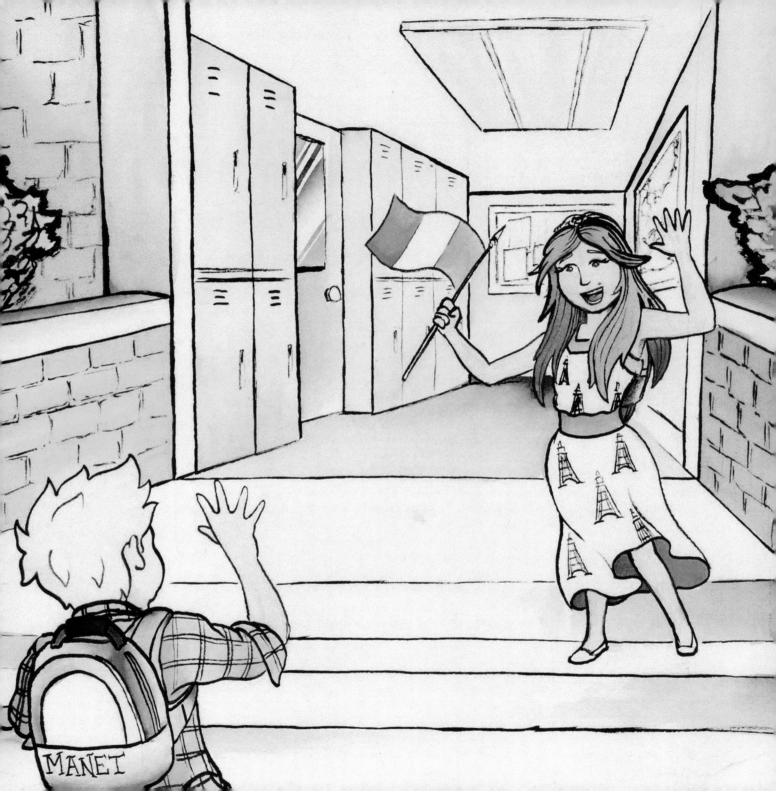

Dancers in Blue (1890)

Paris is thrilled to see Manet in art class.
Eager to let him know, that today's lesson plan,
Is about the famous artist, Degas - at last!
She wants to shout, "I'm his greatest fan!"

His art is displayed, all around her ballet studio.
At the paintings she glances, while dancing trio.

Paris: "Ms. Simone is my mom and art teacher.
Today, Edgar Degas is the artist she will feature.

I know that she will be happy to see
How I recognize his paintings. Yippee!"

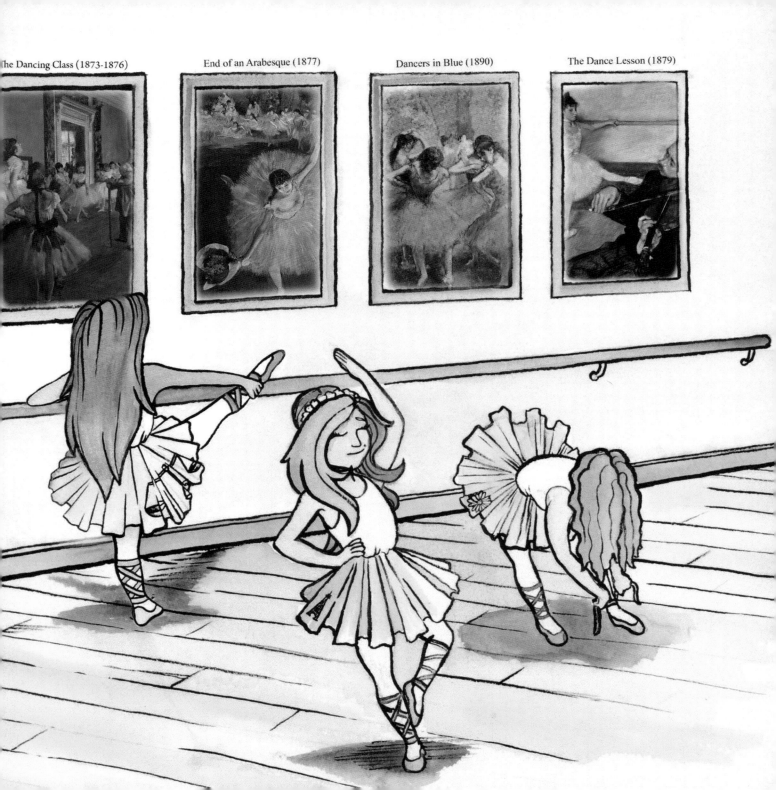

The Dancing Class (1873-1876)

End of an Arabesque (1877)

Dancers in Blue (1890)

The Dance Lesson (1879)

Ms. Simone's class will have fun
painting, movements of dance.

As Degas vividly portrayed
in his homeland, France.

The city of Paris was where he was raised.

His Creole-American mother and
Ingres were his inspirations.

All were impressed, with his brilliant creations.

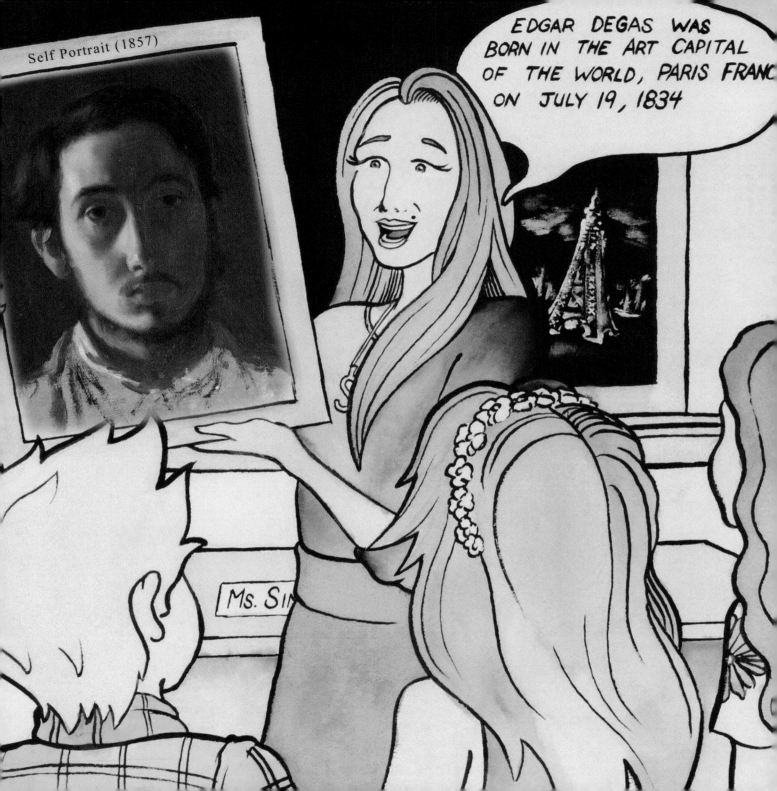

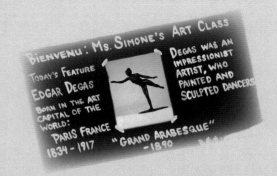

Degas painted and sculpted dancers;
Fascinated by their natural and ordinary gestures.

The body's relaxed pause, Degas observed.
In his work a beautiful silhouette was preserved.

Seen backstage at the Paris opera house,
Sketching ballerinas fast, like Mighty Mouse!

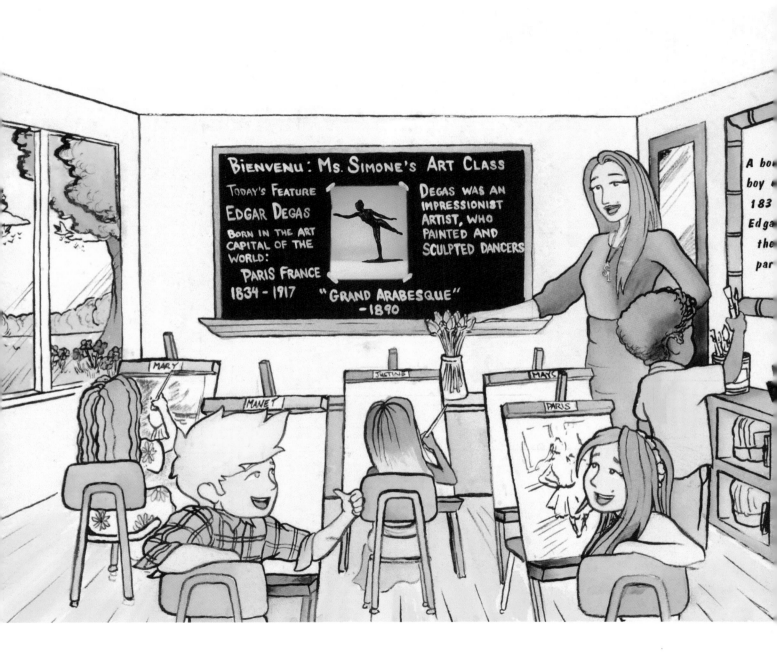

Paris wants to observe and draw,
Recalling movements performed without flaw.

Her mom is standing beside,
Approving while beaming with pride.

"Remember," says her mom, "avoid using black.
Colors! Colors! Don't hold back!

Use lines and shapes in impressionist fashion.
Have fun while creating, and follow your passion!"

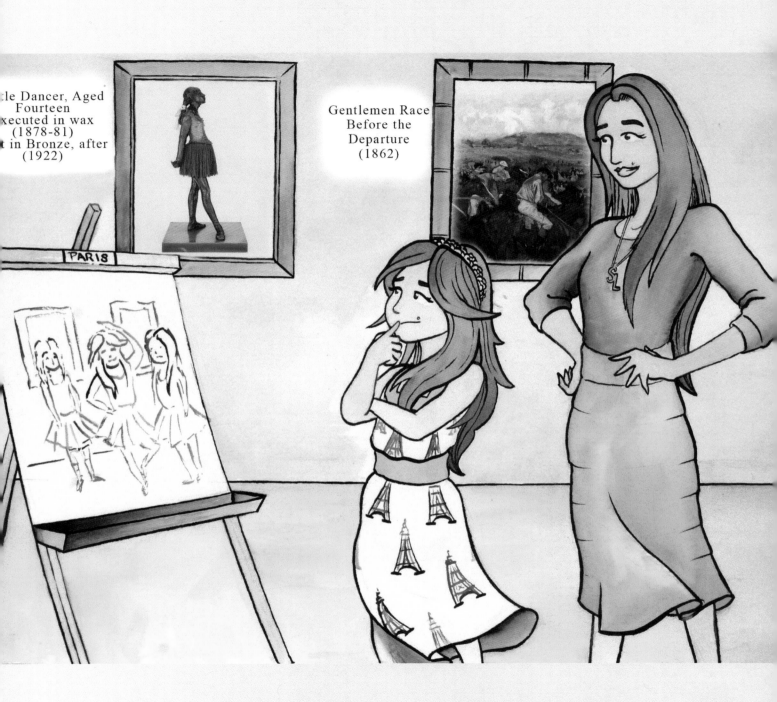

Paris is frustrated.
Her illustration is complicated.

She wants Manet to give her a hand;
Her painting feels still, immobile, and bland.

"Manet," says Paris, "when you paint,
you seem dreamy, yet witty;
Coo-cooey, wackadoey, but your paintings are pretty.

Do you drift off to never-never land?
Please teach me your ways; I want to understand!"

11

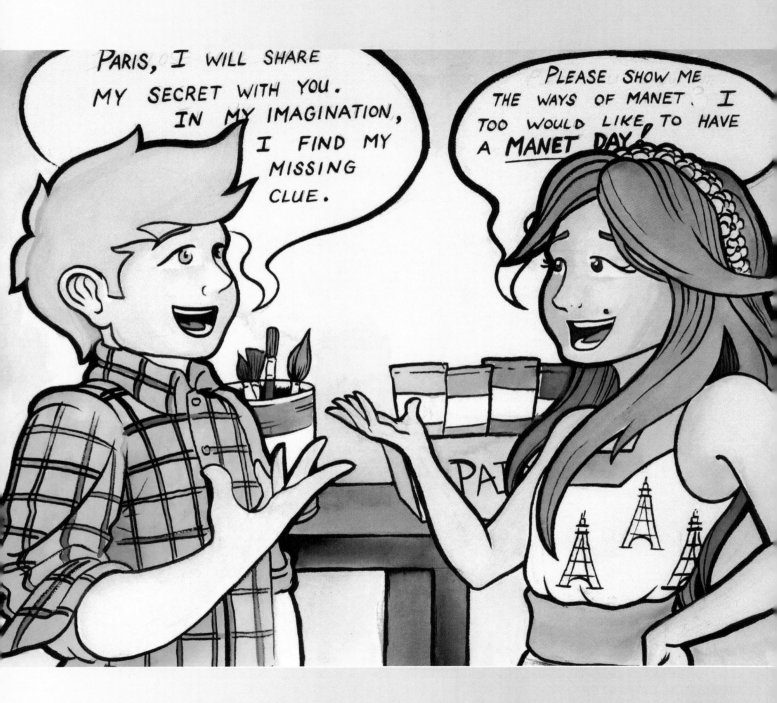

"Paris," says Manet, "close your eyes and do as I do.
In your imagination, you'll find the missing clue.

Being wackadoey will set you free.
Say it three times and you'll travel with me."

"Wackadoey! Wackadoey! Wackadoey!"
And away they blewy!

They dreamed of him and then - Voilà!
Standing right in front of them was Monsieur Degas!

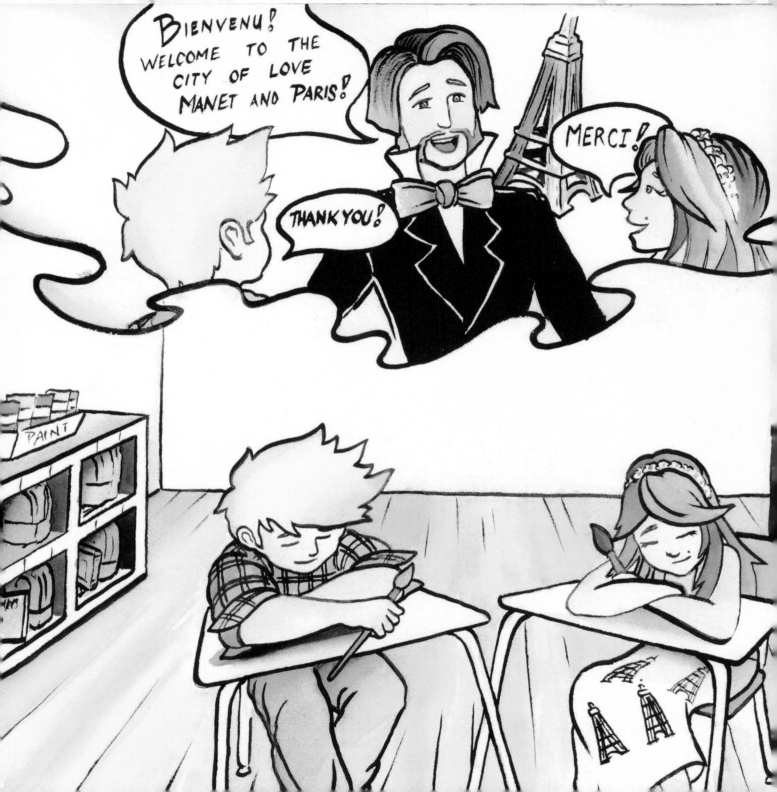

"Monsieur Degas," says Paris,
"I'm so frustrated with my art.
I try to sketch from my memory,
but I don't know how to start."

"Belle Paris," says Degas, "listen closely and observe.
The poses of the dancers, you have to preserve.

Come with me, to the Parisian ballet,
We shall watch the ballerinas and spend the day.

Movements of the dancers,
I capture at the glance of an eye – fast!
Illustrating the famous Parisian ballet studio,
in "The Dance Class."

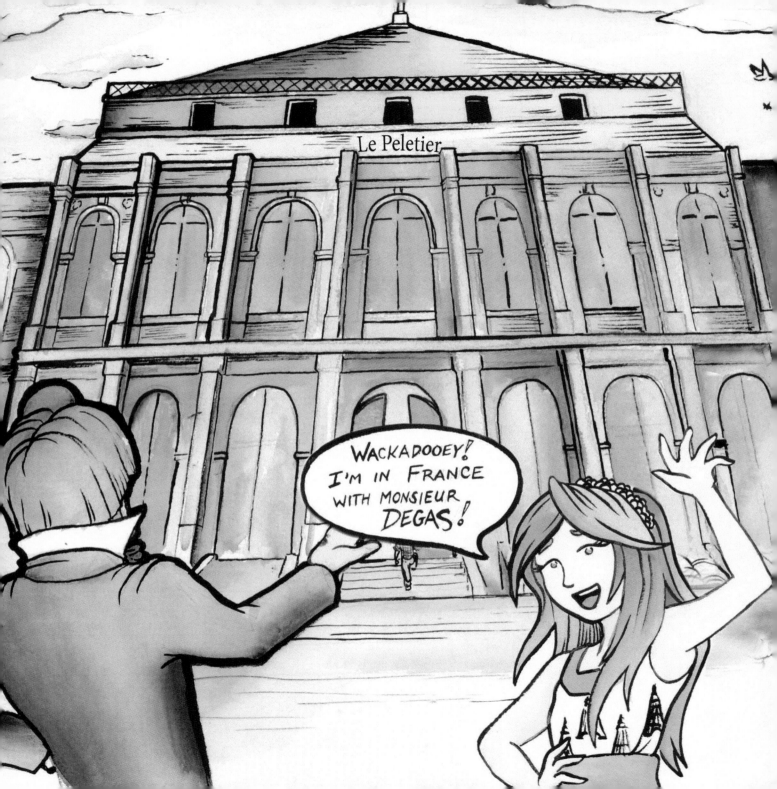

Draw lines and more lines, both from memory and life,
My dear friend Jean Ingres once suggested to me twice.

I paint with colors that are happy, bold and bright.
Utilizing both indoor and outdoor light.

Completing a canvas takes me a while.
As an impressionist, I paint in that style.

However, while others painted fast what they saw,
I like to erase, perfect and redraw."

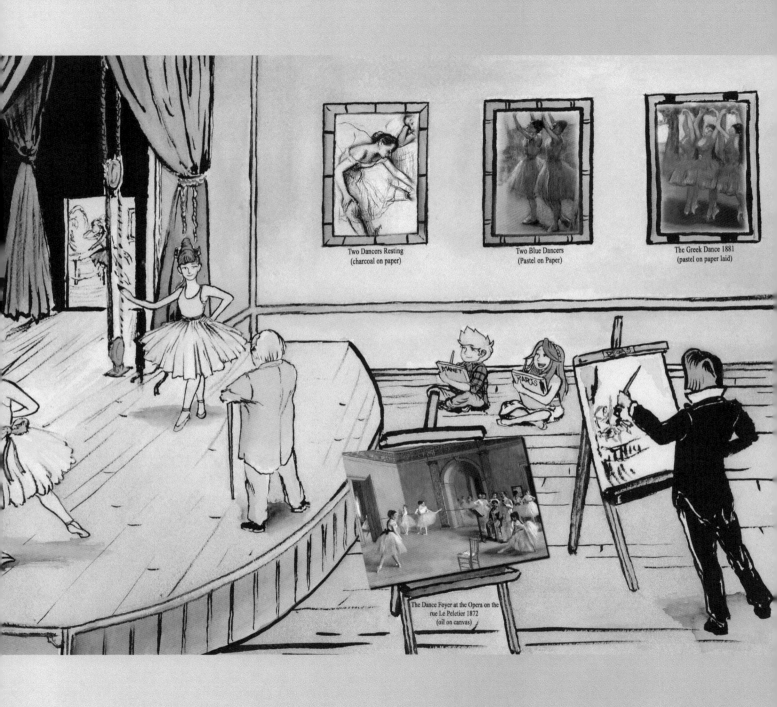

Two Dancers Resting
(charcoal on paper)

Two Blue Dancers
(Pastel on Paper)

The Greek Dance 1881
(pastel on paper laid)

The Dance Foyer at the Opera on the
rue Le Peletier 1872
(oil on canvas)

"But Monsieur Degas," says Paris,
"I can't keep coming here to sketch.

I live in New York and it's quite a stretch.

I'm drawing from my memory, lines and shapes,

Not knowing what else to do, when my mind escapes."

"Paris," says Degas, "I see what you have created,
Your trio on canvas vividly illustrated.

Mon chéri Paris, my passion is to watch and draw;
To capture the essence of the dancers I saw.

In my studio I struggle to recreate their grace,
Their movements, their silhouette, and each beautiful face.

Paris, my suggestion to you is to go back to your ballet.
Bring your pad and sketch all day.

Plié, round de jambe,
will be beautifully displayed on your canvas,
As long as you don't get too anxious!"

Justine asks, "What's wrong with Paris and Manet?

Their minds seem to be so far away."

Mary whispers, "Wake up!
I'm afraid you will get in trouble.

You and Manet are quite the dreamy couple."

Paris says, "Au revoir, we have to head west.

Thanks Mr. Degas, you're the best!"

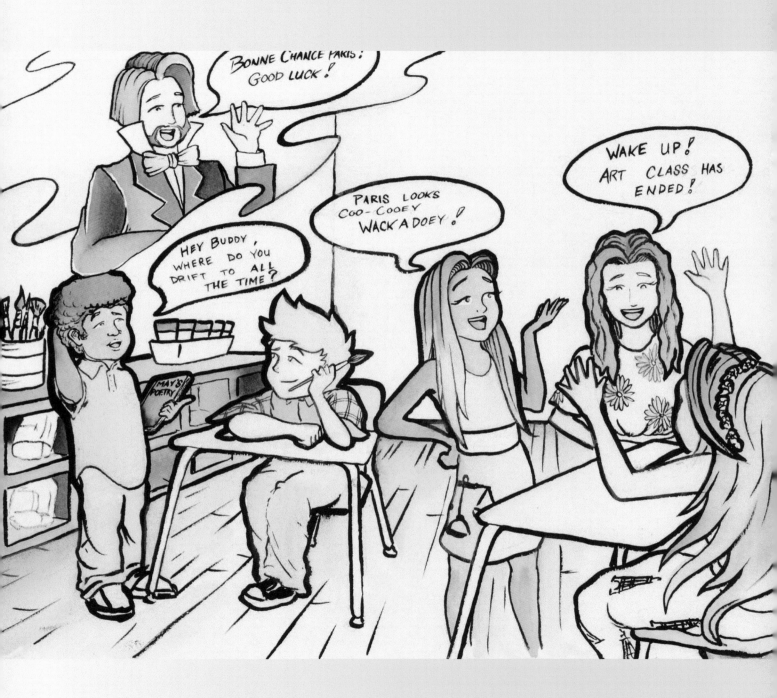

Her mother is pacing.
She sees that Paris has been erasing.

"Paris," she says, "your relève is drawn so precise.
You used vertical and curvy lines, how nice!

Will you be finishing your painting today?"

"Actually, I would like to take my sketch home, if I may.
I want to rework it until it's just right,
Perfecting the movements, colors, and light.

Perhaps I'll start with Mary and Justine.
Their plies are ideal their round de jambe pristine."

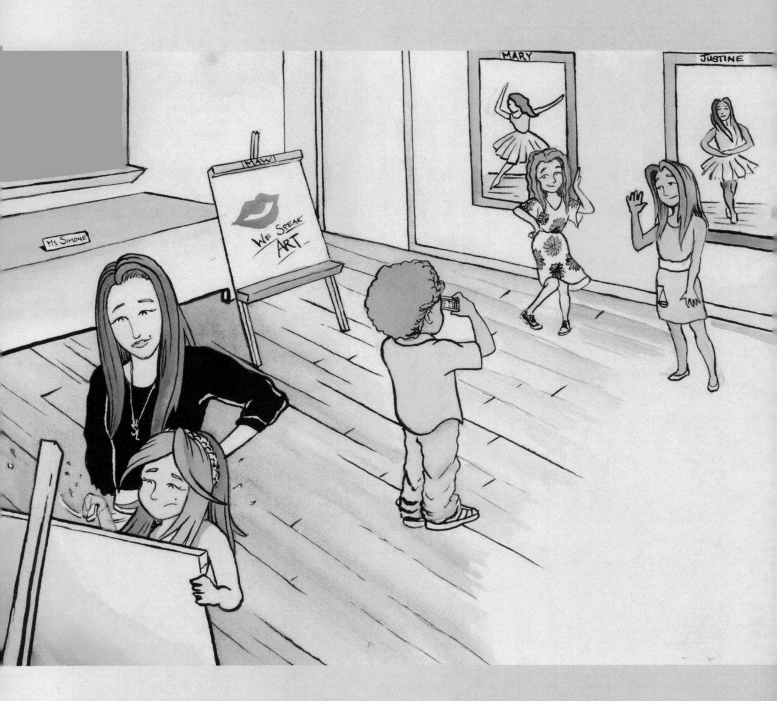

The following class, Paris returned with her finished art.

A beautiful trio portrayed from the heart.

"Degas would have been so proud!"

Her mother said, "This would have made him smile.

An impressionist work, in your very own style."

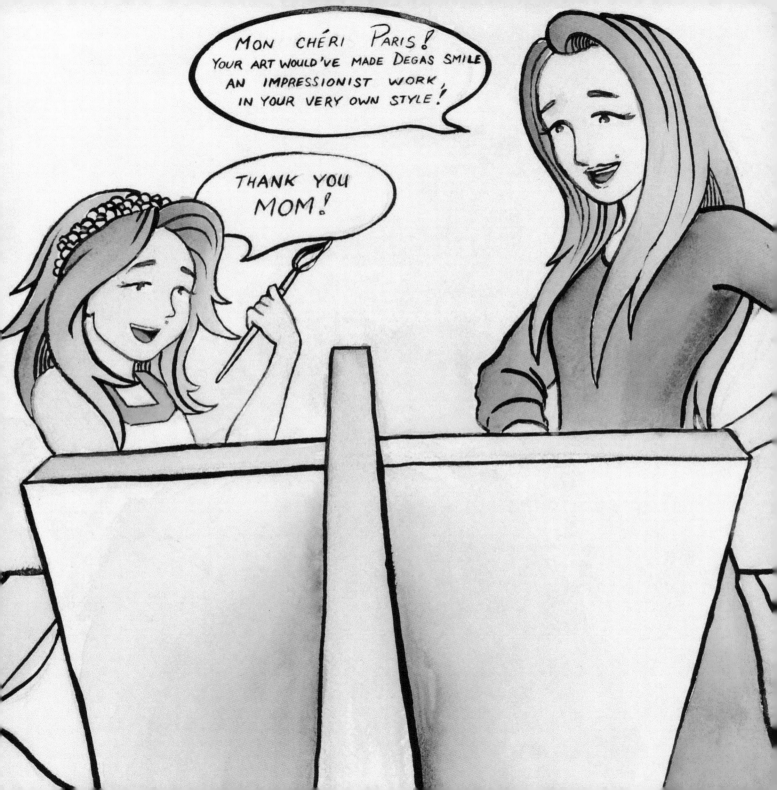

"We'll put it up beside Manet's 'Dogs' and Mays's poetry,

All three beautiful...and perfectly WACKADOEY!"

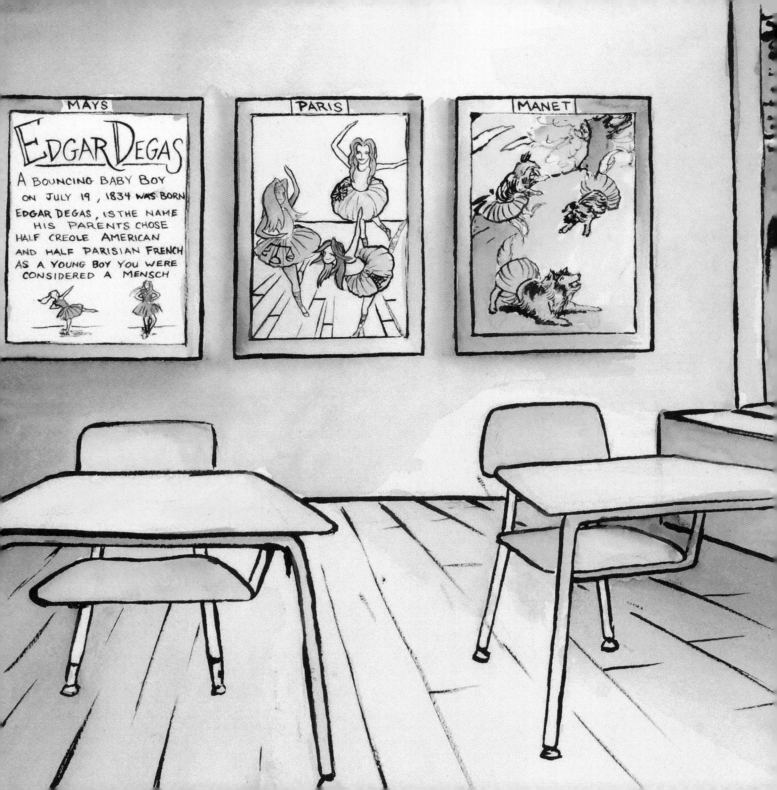

About the Author

I was born in Tel Aviv, Israel and moved with my family to New York when I was eight, which was the same year that the essence of who I became as an adult was born. My brother Donny died of a brain tumor at the age of seventeen. As a child, I became passionate about giving back to the world through charitable works and education. What I was unable to do as a child, I have been able to begin to accomplish as an adult.

Art helps children use both sides of their brains, embracing expression and imagination to create something wonderful. Studying art helps children understand the connections, shapes, colors and ideas that exist in every artist's work.

Teaching art history to children in a way that encourages their creativity and interests rather than being intimidating (or boring!) is what inspires me to teach. The love I have for seeing their eyes brighten and their ideas form is what motivated the creation of MAW and its series of art history books, teachers' curriculums, coloring books, songs and online projects.

I studied economics and sociology at Queens College in New York, followed by an internship at Lehman Hutton on Wall Street. (Yes, even investing can be creative!) As a buyer and merchandiser for Le Firme and later for Akris's at Bergdorf Goodman in New York City, I returned to my more creative passions.

I teach and co-run an art program called "Learning to Look" at the Schechter Day School. I introduced MAW to Cohen's Medical Center and have the absolute joy of watching children immersed in art, being able to forget their pain and their illnesses — even if just for two hours. Watching them experience their own "imaginative ways" impresses in me the power of creativity and artistic expression.

Paris, Manet, Mary, Mays, Justine and Ms. Simone all derive from my wish to bring the gifts of imagination, music, fun and facts to children. My own daughter with the same name inspired the character of Paris. The rest of the MAW kids were inspired by the children that I have watched learn and grow while teaching them about art and creativity.

Ms. Simone is a reflection of how I teach and display art throughout the classroom. I want children to be able to experience art history in a way that inspires them to begin their own creations. All children (and adults too!) should have the experience of being told "Great job," "You can do it," and "Aren't you awesome?" Making art gives children just that opportunity: to express, learn and feel a sense of accomplishment.

Charitable work is a central part of my life. I am a member of the Women's Health Committee at Katz Women's Hospital; a member of the Autism Committee on Long Island; am involved at Sunrise Day Camp, a camp dedicated to children with cancer; and am a member of the UJA-Federation.

I enjoy spending time with my husband Jason and my children Jordan, Logan and Paris. Most evenings, I can be found sitting at the computer dreaming about the next adventure for Paris, Manet and the gang.

Have a fun and wackadoey experience!

Sima Levy

Made in the USA
Lexington, KY
14 March 2014